Our Isles

Poems Celebrating the Art
of Rural Trades and Traditions

Angus D. Birditt
& Lilly Hedley

PAVILION

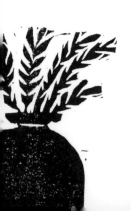

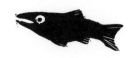

Introduction

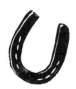

The countryside is the place we call home. There among its rich tapestry of wandering valleys flush with ancient woodland, leaning crowds of fenland reeds, patchworks of fields glowing in all hues of green and blushing meadows lush with seasonal colour, we find our inspiration and passion for life. Although we grew up on opposite sides and terrains of the British Isles – Angus in the flat lands and broad skies of East Anglia and Lilly in the vast hills of North Wales – we have always lived in the countryside. Its abundant nature, diverse landscape, regional and seasonal food and rural communities have always been part of our everyday life.

We met at university, where we found a shared love for the countryside and rural life. Although we studied in a city for three years, our yearning for life back in the country never waned. And so it was decided: as soon as we finished our degrees, we would move – back, in Lilly's case – to North Wales together. There, amid its rolling hills and winding rivers, we set up our food company, which produces and sells seasonal products based on the wild foods we forage sustainably from the surrounding landscape. Each year we travel a lot with the company, attending fairs and country shows all over the British Isles. Every time we step out into the countryside, whether to a familiar or different part of its expanse, we immerse ourselves as much as we can in its landscape and nature, community, crafts and traditions.

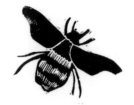

Through the years of constant travel over the British countryside, we have gained a broad knowledge of its rural scope, identifying its distinctive landscapes and beautiful nature, and meeting its rural communities, which teem with remarkable lives, skilled crafts and rich traditions. It was this growing knowledge and experience of the countryside and its people that led us to the idea of founding the Our Isles project, a way to explore the countryside through art, evoking its landscape and nature, community, crafts and traditions for others to enjoy and reflect upon. The poet Edward Thomas noted in his 1913 book *The Country* that perhaps the purest way to enjoy the country was through an art, and Our Isles is a platform for enjoying rural areas through the arts of poetry, printmaking, photography and prose. It is a collection of work that aims to stimulate and encourage the consideration and protection of the countryside.

This book is a collection of work that explores rural life in Britain, and more specifically the remarkable ways of life that exist within the rural community today. There are some truly inspirational individuals who have devoted their lives to sustaining our rich rural heritage and preservation of the land. Through their passionate adherence to traditional and sustainable values, these are the characters who, for us, evoke the life of the countryside most fully. They are the guardians of our landscape, the ones who shape our rural way of life.

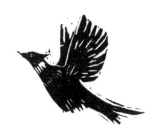

This collection of prints and poems has taken the last
few years to complete, and we created it all based on our
own experiences of meeting and taking time to know
these particular individuals. Forming part of the Our Isles
project, the book follows thirty people who are embedded
in the countryside, many of whom we are now proud to
call our friends. Each life – from artisan food producers to
craftspeople, naturalists, farmers, cooks and writers – has
been evoked through text and image. Each poem is meant
to give the reader a feel for the individual's routine and
the rhythm of their day-to-day life, while each print offers
a snippet of their surroundings. They come together to
capture the *essence* of the subject's life. We want this book to
encourage people to visit the countryside, to look after it and
view it from another angle. That is to say that this book is an
ode to the countryside and its rural communities.

For the rural lives in food, such as artisan producers, farmers
and cooks, we focused on those who were supporting
sustainability, were certified organic and used locally
sourced produce. The research for these people took us to
the furthest corners of the British Isles. The food producers
we visited were artisanal, making products that are unique
to our country, from specific county cheeses and special-
breed meats to harvested salts and regional wines. The
majority of the food producers were award-winning or
included in the Protected Designation of Origin scheme set

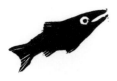

up by the European Union to guarantee and highlight food's geographical and traditional importance. The cooks came from all walks of life and all had the same 'field to fork' ethos as us – not forgetting to mention our mothers, of course, who were our inspiration when growing up. The farmers we came to know well were all local, organic or regenerative farmers. Each of them focused on low-impact farming, prized the quality of their meats and breeds and planted nature-friendly meadows on their land to reintroduce endangered wildlife and ensure future sustainability.

The majority of the craftsmen and women were renowned in their craft. We met, watched and, during most visits, tried our hand at their particular crafts. We travelled to a bakery in Orford where in the early hours we baked alongside esteemed bakers; we harvested white flakes of sea salt on the shores of the Menai Strait; we met several cheesemakers to help in the making of some acclaimed Suffolk and Shropshire cheeses. We ascended hills to help dry stone wallers build new walls with traditional means and rebuild old drovers walls back to their original state; we met blacksmiths who weld benches that would adorn the summits of Welsh mountains and met thatchers who came from a long dynasty of thatching or were completely new to the craft.

We also wanted to capture the lives of people who had a great understanding of the landscape and its nature; their

knowledge was their craft. For example, the birdwatcher, shepherd, gardener, beekeeper and poet all have a strong connection to and observation of the countryside. We visited many beekeepers, from novices to masters; gardeners tending to their own patches to head gardeners managing large estates. We have included the gamekeeper in this as well. We have had good relationships with gamekeepers who have a deep understanding of the land and wildlife and take as much care to support them as they do for their own game; these are the gamekeepers we celebrate.

We want Our Isles to be not only an artistic celebration, but also a support to the continuation of rural heritage and practices within the British Isles. It is not meant to be seen as a collection of work that looks back nostalgically at past endeavours, but one that looks forward to the recognition and sustainability of the crafts of the country. We all need a connection to the landscape that surrounds us, whether that be the sea, river, stream, mountain, hill, field, fen, woodland, village green, town or city park. To know the land and the people that work on it is a sure-fire way to respect and sustain it for our children and their children. We owe it to them and to the land, so let us enjoy and cherish these rural lives now and in the future.

At Home

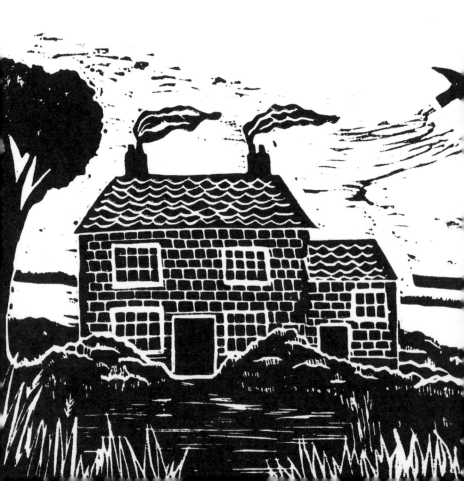

The heart of home is where they flee
Amongst their thoughts to unwind and see,
At one with self, content to be
In space to find and wander free.

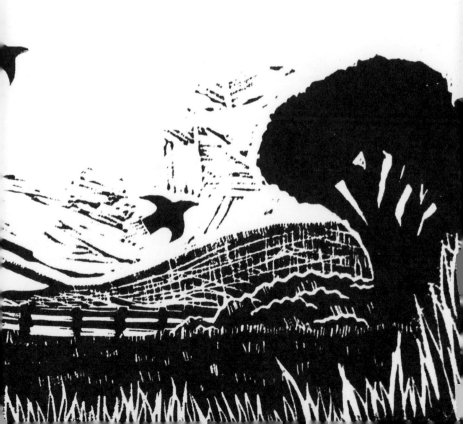

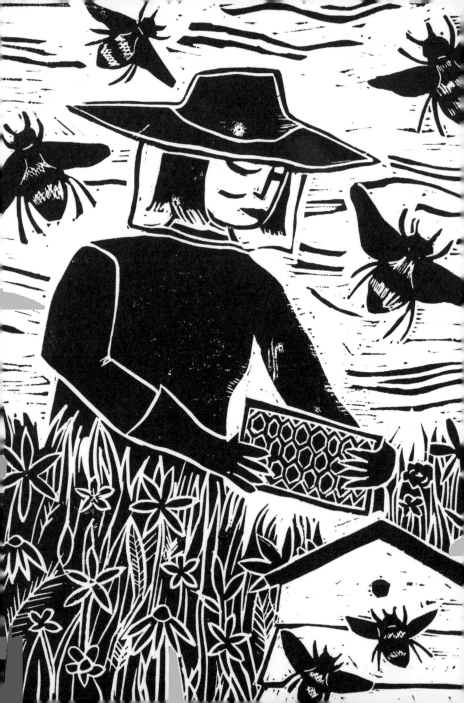

THE Beekeeper

See those that choose a life to keep
Watch the land for knowledge deep;
Come first sign of blossom light
They set their hive to take in flight.

From winter's depths they're quick to rise
To greet the spring and glittering skies,
When nature carries all colour and song,
The bees will line her meadows long.

In summer time, with little doubt,
With careful hands they venture out;
All keepers know when best to take,
Listening to the sounds their bees will make.

Knowing to miss the flight of bee
They'll singe a rag for smoke to see,
And pump the bellows to start the flow,
Dressed in cotton from head to toe.

Passing guards 'mid masking scent
They find the hive in calm content,
Then slide each frame with gentle hand
To miss the bees that care to land.

Come harvest sun, the nectar's set,
Gathered in from a thousand met;
The keepers press to start the strain
And watch the wonder of honey drain.

Once the care of ancient monk
Who took the hive from hollow trunk,
And downed the honey for keeping well,
To rid themselves of ache or swell.

Whether honey comes in golden hue
Depends on land and flora too,
For an early bud in blackened thorn
Will see its tinge like an autumn corn.

Keepers of bees are craftsmen too,
That mend and make their hives anew.
Such thoughtful minds who tend our bees –
How dearly we need some more like these.

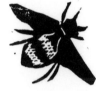
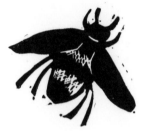
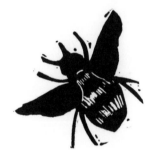
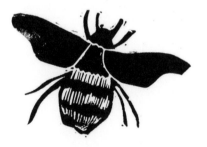

THE
Gardener

They make such places,
A home in the outdoors,
Where walls are thick with blackthorn or box,
Where the robin sings and the cat explores.

For this kind is special:
Those who side with floral care,
Trim and tender to their bounded havens,
Near flicks of wren and wandering hare.

Come the rains that shine and fall,
And frosts that burn the backs of throat,
They who muddy their weathered hands
Brace each season with faithful coat.

Many will aim for a sculpted lawn
Where weeds are seen as a plague of sort;
Yet others leave a world so wild
For bees and bugs to roam and court.

Pray throughout our cherished lands
For those who lust for the life of wild,
With meadows set in scented flowers,
Who try and show all soul and child.

Such folk that choose to grow their own,
Feed our birds and plant for bees,
See them as among our island greats
That help upon their hands and knees.

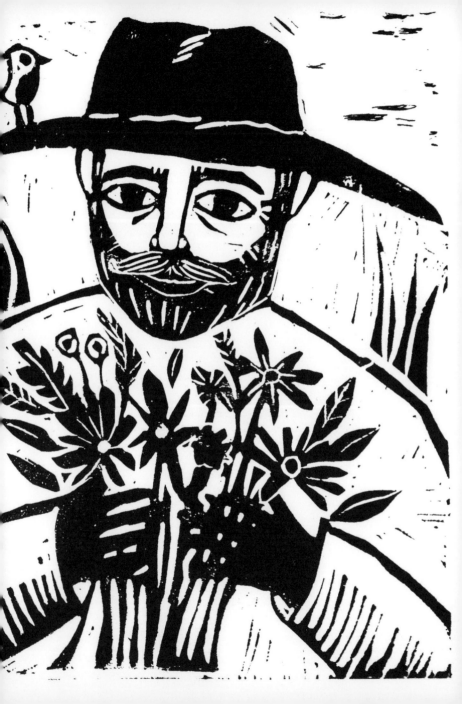

THE
Henkeeper

The light is just, the morning young,
The sky yet filled with the thrush's lung;
When most still lie in the splendour of sleep,
These folk arise each day for hens to keep.

See her wade through quiet land
To feathered friends with caring hand,
Where beneath the quivers of aspen tree
She creaks the door to bolt them free.

Come fluttered flight, her ladies sing
With shakes of head and beating wing
That cues the dawn to burst in call
When nature's chime wakes one and all.

With daily feed and straw to clear,
The keeper comes like mother dear,
In time to gather the eggs that lay,
Soon to be fried to start the day.

Yet 'fore her call of breakfast comes,
She mends the fence and tends the runs,
To guard her hens from prey and fright
That sulks amongst the blackened night.

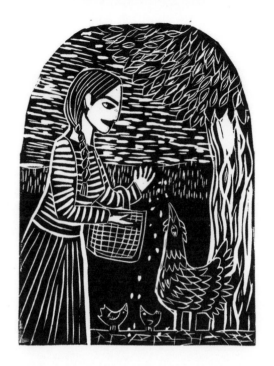

Then through the day in pleasure still
She sees them worm and dust at will,
'Mid clover flowers and stags of tree,
They'll come when called and perch on knee.

Too well she knows their daily greet,
Their hungry cries, their rushing feet;
How folk alike with caring mind,
Find a charm in each of kind.

Till dusk arrives to take them in
From lea to coop and warmth within,
For like her brood, by routine led,
She soon will lie her heavy head.

THE
Idler

The truth be known
Of those, it's said,
Who flaunt their lives in idleness led;

For whom time abounds
In blessed kind,
Passing it by in frivolous mind.

For come he must
To meet the day,
And rise in usual listless way.

At first to flounce
On shingled beach
With toe to wet, come tidal reach.

Then off he roams
'Mid hive of bees,
Hearing their drone amongst the trees.

Lastly, to dawdle
In lengthy hour
Rambling past the season's flower.

How such a day
Of work and do
Leaves little time for much anew.

No chance at all
For passing fraught;
Only time to rest and lie in thought.

Such a busy soul,
To those who asked,
A life in full, so wholly masked.

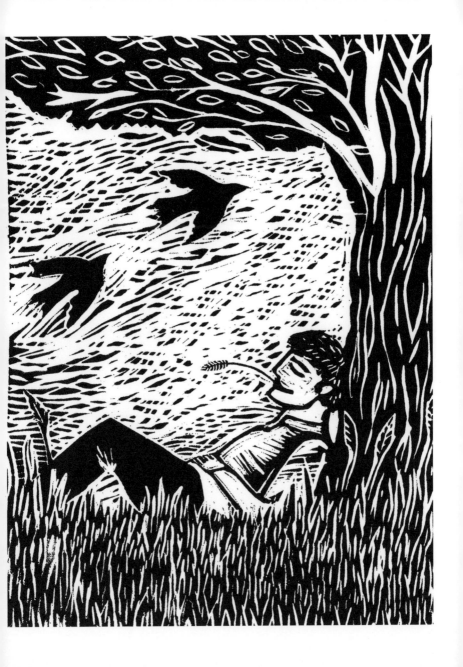

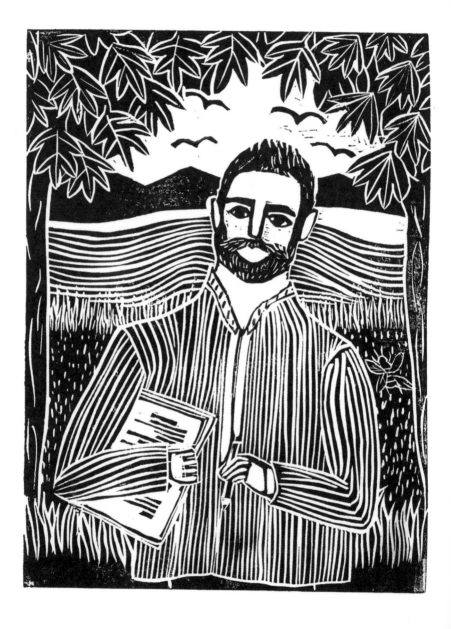

P^{THE}oet

See him scale the heights of vale
And trace the paths of ancient ways;
See him perched on village green,
Capturing life of passing scene.

See him under wisps of ash
To hear the swells of warbler sound;
See him hike where coppice stood,
Crafting verse, through enchanting wood.

See him rove the banks of Dee
And watch him pause and ponder life;
See him reach the sheltered bay,
Trying to light the clouded grey.

See him climb past upland ling,
Atop the peaks to mountain cairn;
And see him hail all migrant bird,
With detail placed on every word.

For come the time and mindful space
He finds a way to write in place,
To seize a thought or sense profound,
To last in word, his memory bound.

Through Busy Streets

See locals smile with hand to share
'Mid merry murmurs that flood the air,
Through open doors they're welcomed in
To the life and craft that stirs within.

THE
Baker

Come any time you wish to see,
For our baker folk will always be
The first to rise at early hour,
Mixing water, salt and flour.

While we rest on our peaceful own
The bakers begin the morning alone,
When only birds, who are yet to sing,
Are present to hear the mixer's ring.

All types they make, from loaf to bun,
In time to meet the morning run,
But they'll have to wait to raise the sour,
And turn the dough each half an hour.

Their palms, so used to knead and fold,
Give little thought to shape and mould;
Some need no scales, they judge so well,
Their learned hands can rightly tell.

In bannetons they prove before
They're crowned with flour and knife
 to score;
Then all are baked with crust on top
For passers-by to come and shop.

They who make our farmhouse bread,
Where salted butter is slathered to spread,
Over fires they char our sourdough black
And raise the crusts that soon will crack.

Those long hours spent on working dough
We seldom see or rarely know –
So here's to you, our island makers,
We sing your skill, the craft of bakers.

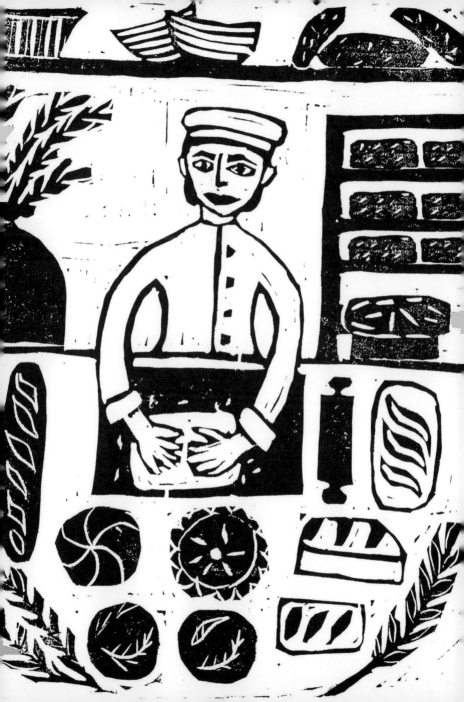

THE
Brewer

First they malt the barley to taste,
And mash in tun to turn and scent,
Then start the strain of 'God is Good'
To work the wort, now wait they should.

In every place you'll find these folk
Who brew in houses of any kind,
Past County Down or River Tyne,
They map our streets and coastal line.

See them along industrial belts
Or under the ways of railway lines,
From the hills that start the Dee to flow
To the peated fens that lie down low.

When came the time of frequent Act
To rid the gin from every lane,
Our brewer folk were held up high,
And fuelled our land with beer to buy.

Forever we'll see the brewing mind
Siding with those of the crafted kind,
From folk producing a home-brew batch
To family names making thousands to match.

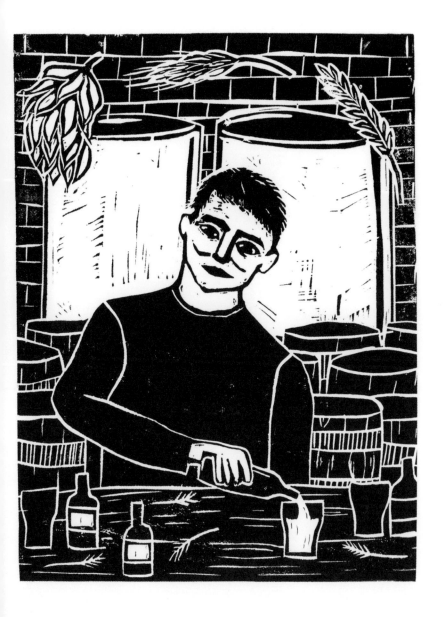

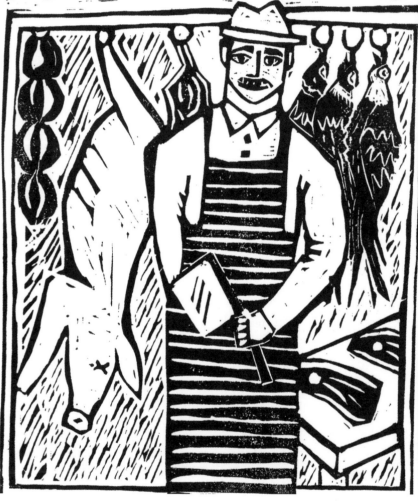

es & son · Butcher

THE
Butcher

Through sounds of bell and voice he greets,
Down village lanes or busy streets.
With a sprightly grin he asks, *Are you well?*
Showing the work he is eager to sell.

Many who've learned by their fathers told
Have pledged their lives to this craft of old;
Just ask their thoughts on which cut to buy,
For they'll know best how to braise and fry.

The decent kind will tell it true,
Their source of meat and how it grew,
Whence it went for its life to end,
And the length it's had to cure and spend.

Folk who know their farmers by name
Are sure to trace from which breed it came;
They will keep the fat and marble through
And offer methods and timings too.

Behind the counter of well-ordered meat,
He'll soon suggest which lamb or pig to eat,
Perhaps the game that's in season most
For the weekly supper or Sunday roast.

Over wooden block, with apron tied,
He cuts each carcass with skill and pride,
Without a thought he's quick to slice,
To brush the bone and dress to price.

He can cut your chops or steak to size,
Crown the ribs and cook pork for pies,
Mince the shoulder to fill skins, then tie
With seasonal herbs and toasted rye.

A life to love, they'll all agree,
Living by locals and cups of tea;
Where trends pass and times will change,
Tastes evolve and products range.

THE
Cook

Come hither during morning call,
Or deep amongst the twilight fall,
As she tempts you in with drifting smells
That stir within where her kitchen dwells.

So follow through, for soon you'll know
That comforting smell of baking dough,
Now freshly cooked with loving care,
She's ready to make a feast to share.

With trusted knife and board in place
She runs her blade with heedful grace
Through seasoned vegetables of her own,
Picked and sought whence they were sown.

Watch her clang the pan on heat,
Pour oil and butter to melt and meet,
Hear sizzles of root as she stirs to glaze
And floods with broth for tender braise.

Savour the wafts of sweetened earth
That fill the room for all they're worth,
She seasons a little to balance still,
And finish her dish of crafted skill.

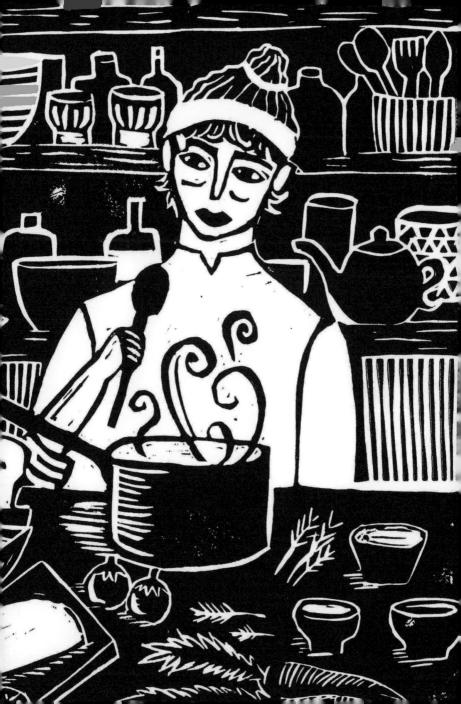

How chefs live on every street,
Through kitchen doors in flavoured heat,
Stretching forth upon rural lands,
In country pubs and festive stands.

See fires ablaze on isle or beach,
Where they sear their catch from local reach,
For most reside in kitchen home,
The heart of where our memories roam.

Come season in, these folk will know
The time to pick or leave to grow,
For all who know their source's names,
Will side with food, where pasture reigns.

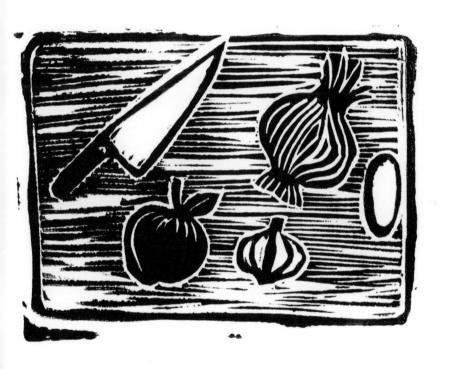

THE
Cheesemaker

She rises amid the morning's black,
Through parlour to barn with next of kin;
Under sharp kewicks of a passing owl,
Each milks their heifer with a cheery grin.

First she channels the milk to warm
In jackets of steam she tops them full,
Then starter goes in before rennet begins
The curds and whey to split and pull.

Next she drains and leaves the curds
In flaxen colour and textured light,
And squeezes still for a drier end,
The smell and taste to each one's delight.

Finishing off with a toss of salt,
She packs each mould up nice and tight,
Stacking them high in the ageing room,
Each cheese aligned in ordered sight.

Now she waits for weeks on end
'Til all the moulds are spun and ripe,
Only then, she cuts and crumbles through
To taste each one and every type.

How far we've come in such little time,
Since cheese was made on wood and fire,
Still now she works her ways by hand,
With metal bowl and heated wire.

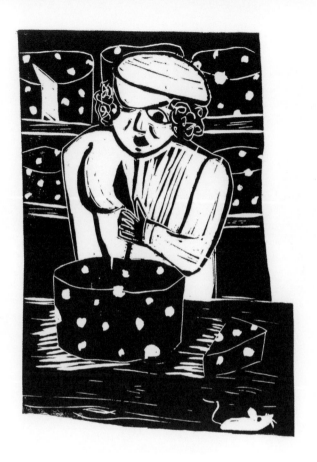

These folk alike know no other life,
Their roots planted in traditions old,
And keen they are to hand it down,
To child to take the reins and hold.

Like fathers and mothers before them now,
Who pressed and stirred with dogged will,
We must treasure those of learned hand,
Who make and mould with ancient skill.

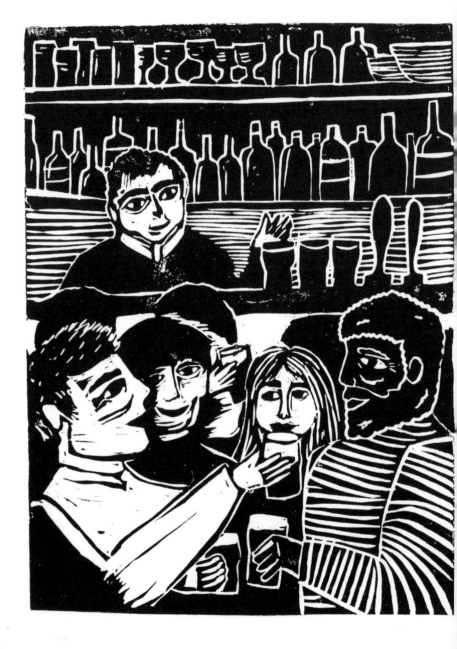

THE
Publican

They are the heart of any street,
Who share their room for souls to buy;
Such folk that lead with warming greet
For anyone or passer by.

They rule the roost from day to late
With taps aligned to wait their call;
For time alone or fancied date,
Their doors ajar will welcome all.

How soon they come to wag their chin
With those that dine or choose to stand,
Down village lane or town akin,
They sink their blonde or bitter hand.

Proud beneath the signs they hold,
These lords and ladies of taverns too,
Will shout and sound their bells to fold,
And call *Last round!* for closing's due.

Yet past the hour, when all are clear,
A flask of rum that's hidden from view
Is placed upon the bar to cheer
And while away the night anew.

With Tool
to Hand

They who work with blade of sorts,
Their practised hands, no second thoughts;
Are one with tool to craft their art,
With eyes set and steadied heart.

THE
Blacksmith

Hear deafening chimes of iron twists
'Mid sooted walls and tightened fists,
Round crafted ash that sets the beat
And light in flame of spitting heat.

Come find the type through darkened sight
That glows beside a flame alight,
With burning brow and hardy soul,
They sting the air with charring coal.

On anvil side they blow to hear
Among golden sparks of showering tear,
Where bars of iron are stoked to glow
In amber light they draw and throw.

With tongs to hold the ore in place
They bend and punch with practised grace,
As they've done for a thousand years,
With name of 'Smith' to prolong their cheers.

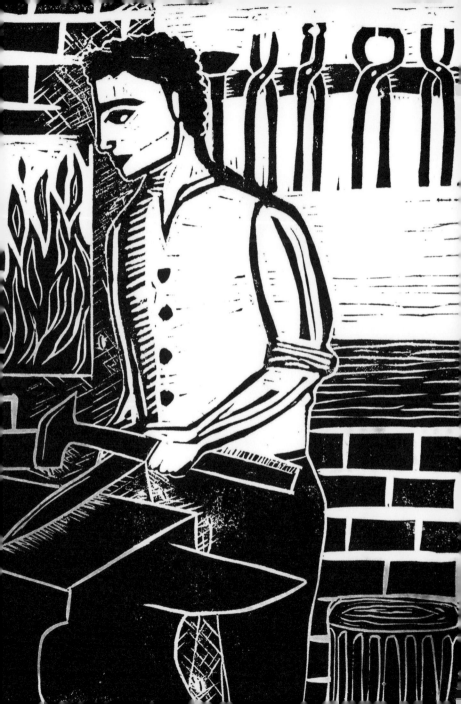

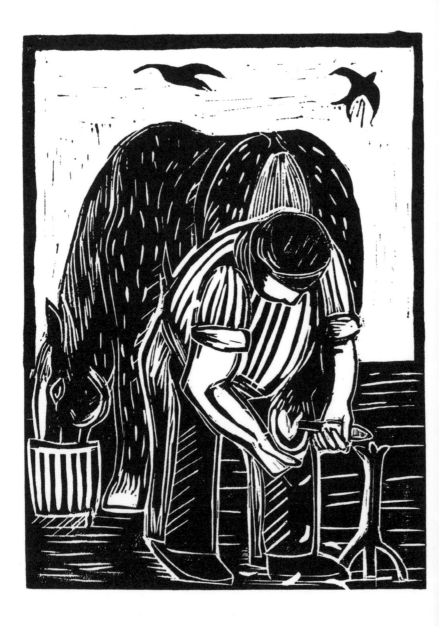

THE
Farrier

Come any day and through any hour,
You'll find these folk by horse of kind,
Taking hold of their heel and foot
In autumn's frost or summer ray.

They see each filly and mare of old,
And know them better than any will,
For their hands have come from a bygone era,
And soled the hooves on which history sang.

With box in tiers and full of tools,
They punch, rasp and stand to hold;
In bonds of steel they stamp anew,
Their hands so skilled in perfect mould.

Hear rings of hammer and wisps of file
As they ease, trim, size and stud,
'Mid trot of horse and shuffling feet
That families past would know too well.

Some reside for furlong and race,
When shoe is light and team comes first,
While others choose a life alone,
That keeps the past in modern tow.

Against the flame with which they burn
And sting of hoof that clouds the air,
Little has changed on their journey here,
The same for close on a thousand year.

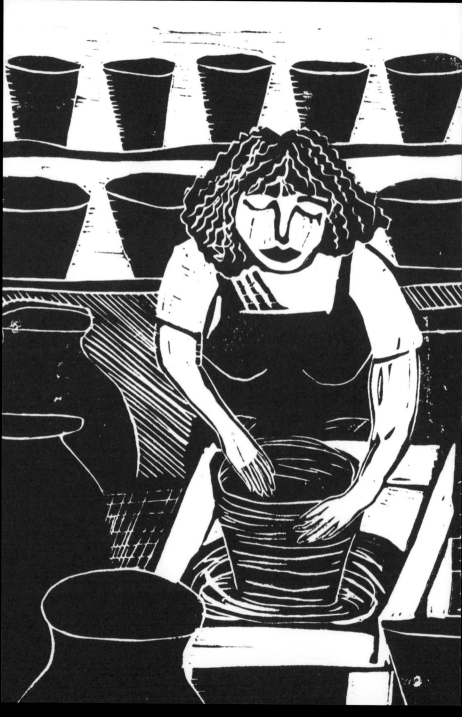

THE
Potter

In balanced thought they perch aloft
On stool, with soles to drive the wheel;
With body thrown by wetted hand
They spin and shape with steady feel.

While weighted palms still centre in
They run the sides with sponge to wet,
For strength they need to hold the line,
And paint the past of history set.

How thought is lost, and senses found,
When stable hand meets spinning clay;
With movements made by beguiled minds,
Their tips will guide in natural way.

Soon to close and refine the line
They top the wood, the fire to blaze,
Then air them dry for final time,
And light the kiln, 'til morning glaze.

For first they came with clay and coal,
Beneath the heights of local peaks,
To fill the bowels of bottled bricks
That rose above the towns of six.

Now those that lead their lives to throw
Have learned the ways of those before;
Their days will pass with hand on earth,
And soon become of master worth.

THE
Printmaker

First they map their mind in full
Of nature's sort or past recall,
Which stirs the urge to sketch away
And draw a course for their blade to play.

With palm to ash and block defined,
They set their line with relief in mind;
Hands that shape their wandering thought
In studied line, for memory caught.

With constant hand they cut to see,
In favourite place they tend to be,
Their rhythm takes a hold to go
And carves the way for ink to flow.

For soon you'll hear the pastes of ink
In rolls that shine for even sink,
With hopeful eyes they press in slow
And turn their prints in eager glow.

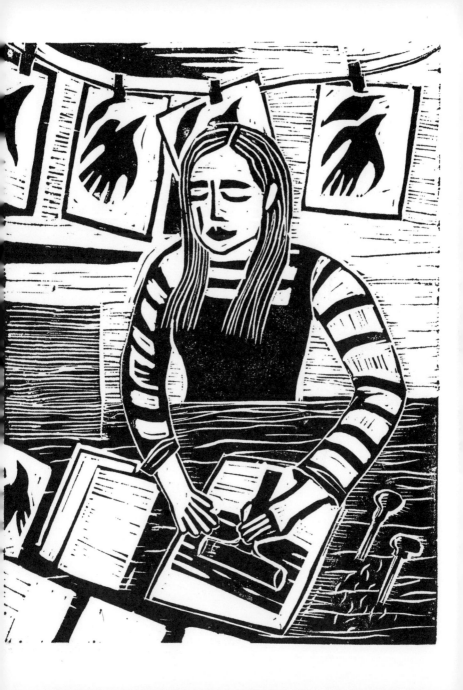

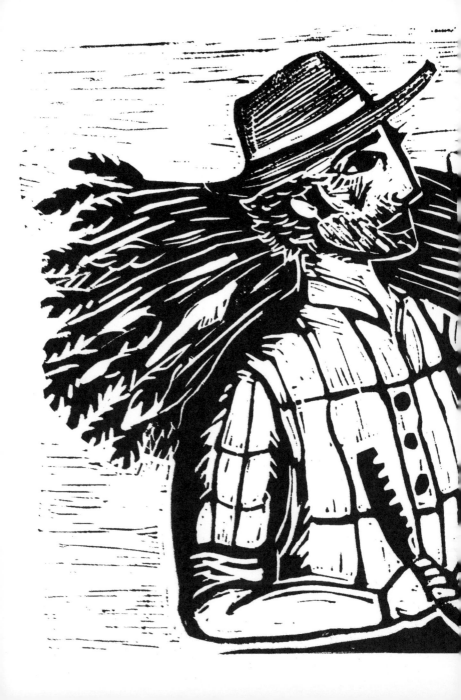

THE
Thatcher

Calmness abounds in this kept country way,
Where the air is lined with sweet-perfumed reed,
Soft thumps of hand heard this fine summer's day,
Upon dwellings they rise with yealms to feed.
Amongst the eaves their line of course is drawn,
Pitched in tight with crook and sway to hold,
With tempered hands twist spars whittled at dawn,
When day be dusk, they fill to fit and mould.
'Til comes the time to scale the ridge and view
To where they're often seen on wooden rung,
Hammering tight their rolls of straw right through
And their thatcher's mark, so proudly hung.
How wonder bestows on these folk that live
The beauty that resides in the craft they give.

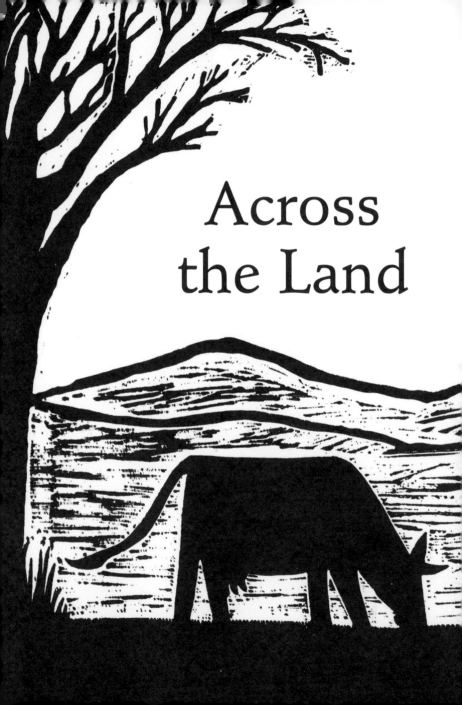

Across
the Land

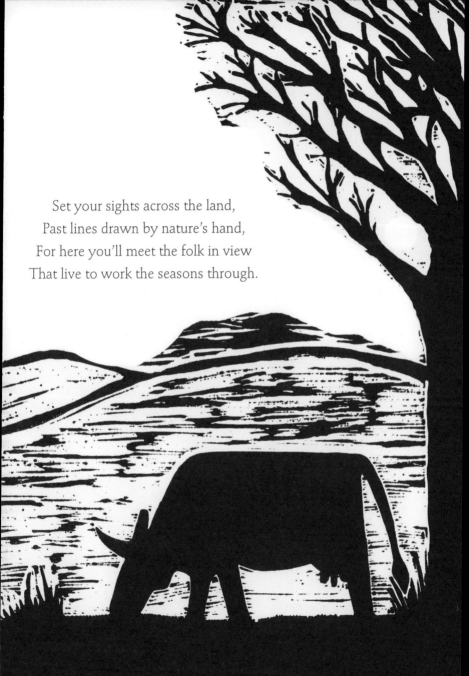

Set your sights across the land,
Past lines drawn by nature's hand,
For here you'll meet the folk in view
That live to work the seasons through.

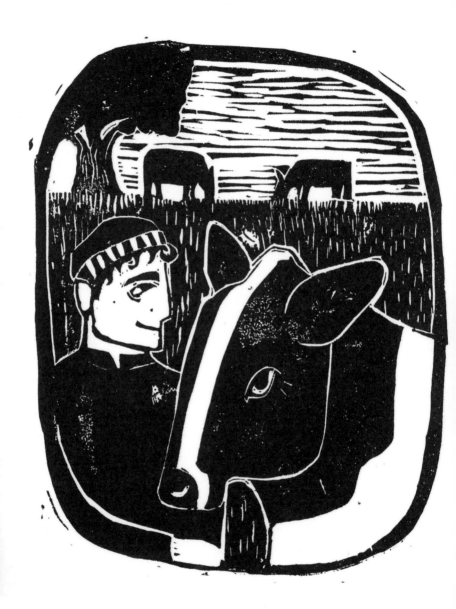

THE
Dairy
Farmer

How little time has passed
Since his soul was laid to bed,
For he is up again, in darkness still,
To greet his girls and have them fed.

The morning is his solitude
That brings such bliss relief,
A time away to sneak a seconds
Of the missus' last-night beef.

He sees it down with his favourite brew,
Burning pints of blackened tea;
Rattling the door come early air,
His dogs bolt out and charge in three.

How the chilling wind awakens all,
Cleansing the heart with its dampened sight,
Making easy work of tired limbs,
Of those not used to its splintering bite.

His weathered brow and seasoned face
Tell stories etched in days gone by,
One who never cowers from cold,
But starts the day with hopeful sigh.

There upon the field of rye,
He calls to herd of heifer and calf,
A voice steeped in country folk,
Of north and south in equal half.

Tearing short the trodden blades,
Near rubber boot and muddied feet,
He's soon to smell and taste the grass,
To sample what his girls will eat.

From a morning full of udders to milk,
Past an afternoon spent stacking feed,
He looks towards the end of day
To wet his throat with horns of mead.

Now weary with the day at dusk
And full to brim with dinner and tea,
Our farmer ends his busy day,
For soon will come the dawn to see.

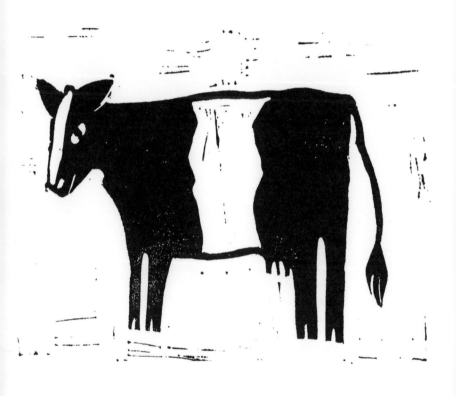

THE
Gamekeeper

One always hears him
Before being seen –
Come, the keeper of game,
And sound your presence.

Among the ancient woodlands
Hiding the running streams,
He's somewhere down the cattle field
Past ranging firs and buzzard screams.

He knows much and varied
Pounds of wheat and barley,
The sounds that rise in fallen night,
All weight of feet and wings in flight.

It's time to feed the chicks,
Each hen and faithful dog;
'Til season comes, his routine cares
Through summer tend and autumn fog.

He lives a life of customs old
That knows the land by hand;
Waits to beat in his Sunday best
When son and heir both proudly stand.

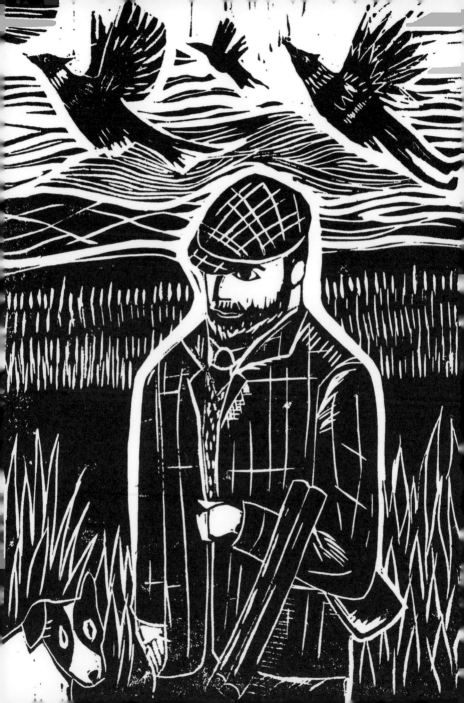

THE Shepherd

From head to source of upland flow
Run the hills with morning dew;
Over tops of heather and scented larch
To the heights of life we seldom march.

Come scale the wild and weathered rock
Where life is quiet and eagles soar,
For amongst these lands of valleys deep
You'll find the kind that herds in sheep.

Amid the chorus of dawning calls
These folk arise with canine friends,
Ascending the hill in twos or threes
To scan the land, all things to see.

With knowing calls his dogs go free
To rush and reach the peaks beyond;
How quick they're off to round up the flock,
Past swathes of gorse and lady's smock.

Their bodies dart the land in black,
Where soon they'll find all strays of ewe;
Swift to move on the knock of crook
They swing to back and crouch to look.

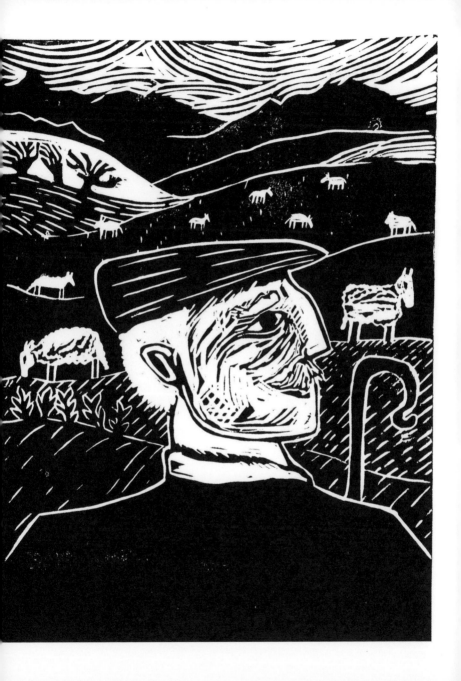

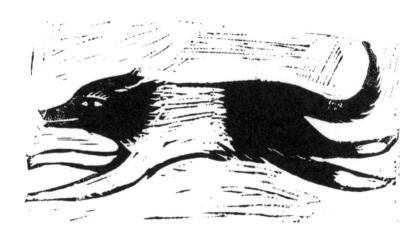

Upon the winds they hear their master's cry,
With each piercing whistle he steers them in;
Down amongst the grazing rye
He leads through race and fold to lie.

The bond that binds shepherd and dog
Is one so strong, of ancient kind,
In any hour or seasoned degree
They'll be out in dark 'til rest and tea.

You'll see the types on market day
With knowing smiles of country faith,
And hear them rabble in earthy wit
To sell their tups and springs to fit.

Shepherds that live for land and flock
Line their course where the winds run free.
Of these 'men of the hills' it's often said
A life of such solitude is rarely led.

THE
Falconer

There are those who walk our isles
With offered arm to seek the wild,
Aligning their path with those above,
Whistling in broad summer mild.

For these are the falcon folk
Who learned their ways from families old;
Catch and care for our birds of prey,
On lines of creance they feed and mould.

They see their birds grow to a pretty beast
Through a mother's call and tender bond;
Each hawk and vulture they lure and knot
Will soon be free in the wild beyond.

Lovers they are for the wings in flight,
Drifting the skies with all beauty of feather,
Creatures that we can only watch in awe,
Jangling in bell and hooded leather.

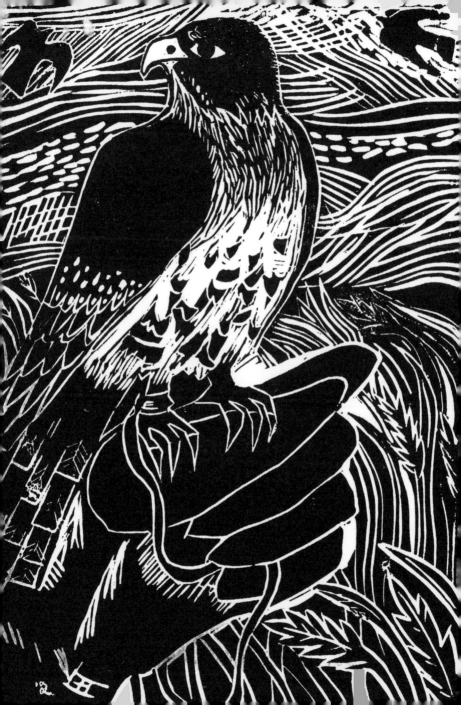

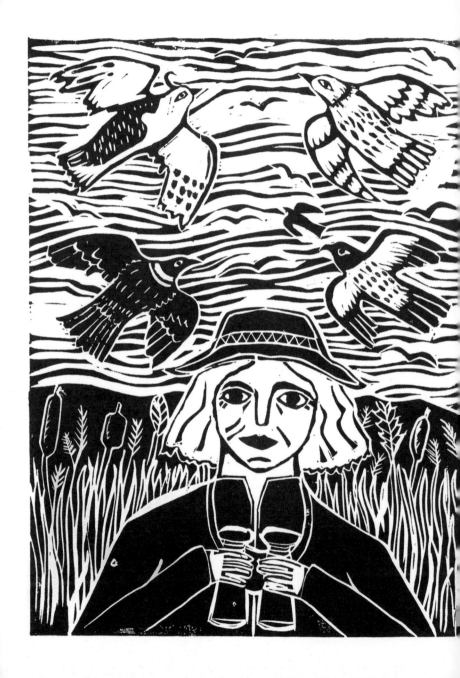

THE
Birdwatcher

O patient soul who drifts the land
With silent feet and steady hand,
'Mid early copse and harvest wheat
Climbs upland moor in hopeful meet.
The watcher stands with solace imbued,
Awaiting a glimpse of feather viewed;
In hide of field, on shining mere,
With glass to eye to bring them near.
Pray cease the breath for presence found –
A male cuckoo harbours April sound;
Nor speak word aloud, for finch will fly
In golden stars that charm the sky.
So quick to know melodic song
Of swallow chatter, midsummer long.
Come lie and watch, amid the shade,
And cheer the flight that nature made.

Down
to Earth

In ancient wood or barley square,
They know the land and soil care,
To gather in or sow it where
Is best to grow for fruit to bear.

THE Ploughman

There he trudges in muddied land,
Towing blade and plodding beast,
To line the earth in ways of two
He cuts with pride and solid hand.

With seed to plant their harvest's worth
He comes in spring and autumn's turn,
To start the plough from headland in,
And set the stetch to break the earth.

You see him proud in morning light,
Upon the field with collared horse,
Marking his line to furrow straight
To lie the land 'til day be night.

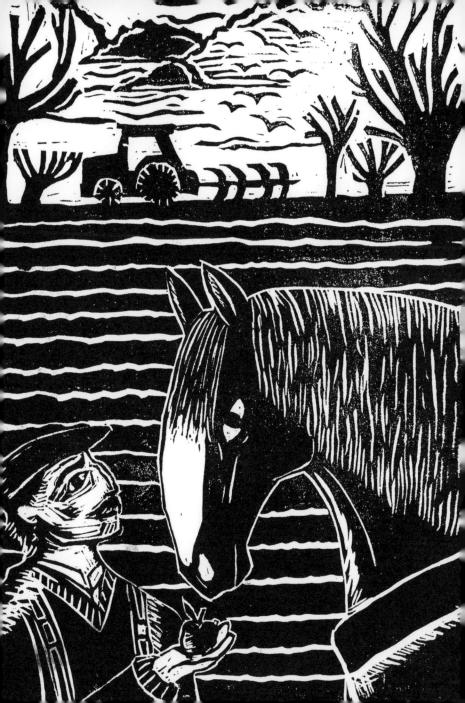

He walks the plough in equal round,
Etching furrows on land and face,
For each were carved to line the last,
And see the harrow on level ground.

But first to lunch, for he's often known
To line his belly with bread and cheese,
With summer's pickle and bitter cress,
All from those that were local grown.

Come the time for the tilth to take,
The sow of seeds for wheat and corn,
With lip in hand or fiddle to seed
He sets to work with equal shake.

Bound to horse through season long,
He craves the pull, come early morn;
For the bond between this man and beast
Sees their love grow ever strong.

How once the seed was rolled in place,
And schoolboys came to pick the stones,
When caddows fled from the girls who sang,
Together as one, each with reddened face.

So pass the pickle, cheese and bread
To the folk who know our land so well,
Come harvest time, with dolly and song,
We wish them well for the year ahead.

THE Dry Stone Waller

They who make such stable dam,
Through generations of learned hand,
Are there to field or side a stream,
And wall our lands of country green.

There to keep our fauna safe,
Channel the flock to dip or fold,
From hungry mouths and preying eyes
That roam our isles under fallen skies.

First they source a local stone,
Then lay it forth to see the size,
And pile away the old for new
That's seen a past of centuries through.

Now to lay foundations strong,
With stones and lifts to build them tall,
Fill with pins and packing to mould,
Finish with covered toppings to hold.

For horse to jump over point to point,
To line the ways of boundaries set,
The want was such in centuries of Act
When commons lost and Parliaments backed.

Once walls stopped the wishful rover
In ordered strips of open field;
Now they're seen as an aged craft,
A line laid out with hardened graft.

They sturdy the face for years to come,
And bole a house for queen and skep.
What folk who make such lines of art,
Let's hope their skills pass to youthful heart.

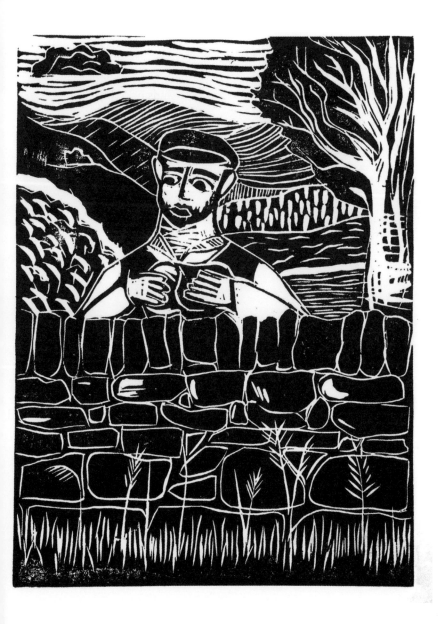

THE
Forester

Their view is one of a thousand kind
In solid spruce or wandering beech;
They know the lie of the growing land,
Where the past is told in scaling reach.

See hands run on arboreal plains
Where minds are mapped and memories sewn,
To study the land and bedded rock,
For all kinds and ages will soon be known.

They count the lines of aged rings
And stand beneath with measured eye,
All senses honed to the life above
With their boring tool and tape to tie.

How some will vie for just timber fuel,
And use the land for their serving rule,
While others align with nature's turn
And work their lands for a wild return.

Through purling brooks and hazel copse
They walk in toe where nature drops,
For they give these trees of social kind
And the life of wild, a peace of mind.

They plant their seed with those above
To know the lives and language of trees
That keep the lungs of our lands in full,
And fill our own with a purer breeze.

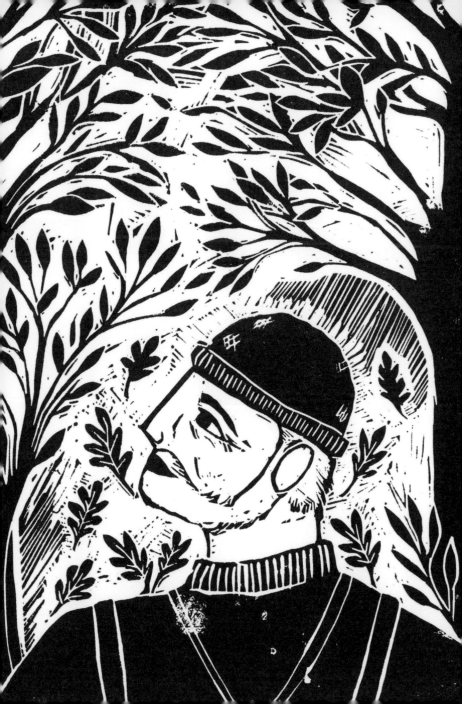

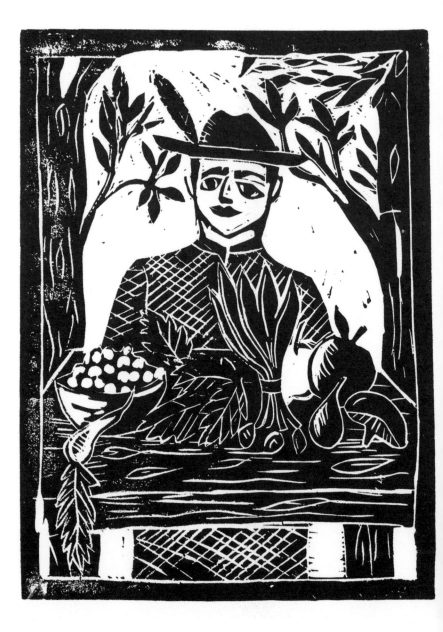

THE
Forager

Our island foragers are rare to find;
Down river valleys or on woodland tracks
They scour the land with knowledge in mind,
Gathering to fill their well-worn sacks.

Those who truly love the land
Take only the portion to rightly feed;
In coves of sea and stretching sand
They delight in finds of berry and weed.

They pick garlic of the wild sort,
And find beet near the raging sea,
Take bistort for a dock pudding,
And pick spring's sweetened cicely.

Go deeper into the wettest wood
To where the best mushrooms grow,
For there you'll see these wandering folk
Bagging blushers and morels on show.

Those who follow the seasons past,
Know to take the best of every kind,
Like wild asparagus that throws its mast
And summer truffles so hard to find.

For once we all were foraging folk
That hunted and gathered upon our land,
Able to stand and feed ourselves
With knowledge sourced from taste and hand.

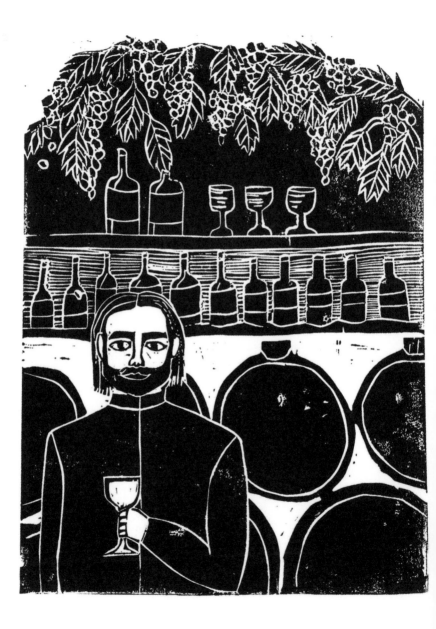

THE
Winemaker

Hidden in cellar amongst steel and barrel,
You'll find these folk too happy to share;
See them stare through glass and gauge,
Sampling their work to ripen and age.

Take hands to gather come summer light,
And hear the prattle of those merry souls
Who harvest their lines of swollen vine,
And fill their sacks on bended spine.

When autumn paints the land outside,
The press is made with stems to taste;
Once laid to rest, they rack and pull,
Come clear of must to watch it fall.

For now the juice begins to turn,
They cool to set and meet with yeast,
Then further treat to flavour still,
Noting tastes with sip and swill.

In winter months they brave the cold,
Prune where they must, and wire again;
See them taken by darkened night
To trap a thousand in sparkling white.

Now comes the time to bottle with cork,
When barrel and drum have given their all;
How proud they are, for their work is done,
So savour each drop – for the drinking's begun!

Amid Tides & Water

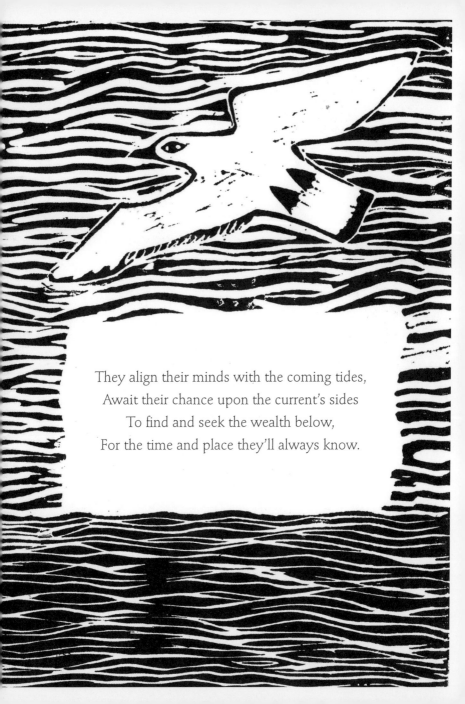

They align their minds with the coming tides,
Await their chance upon the current's sides
To find and seek the wealth below,
For the time and place they'll always know.

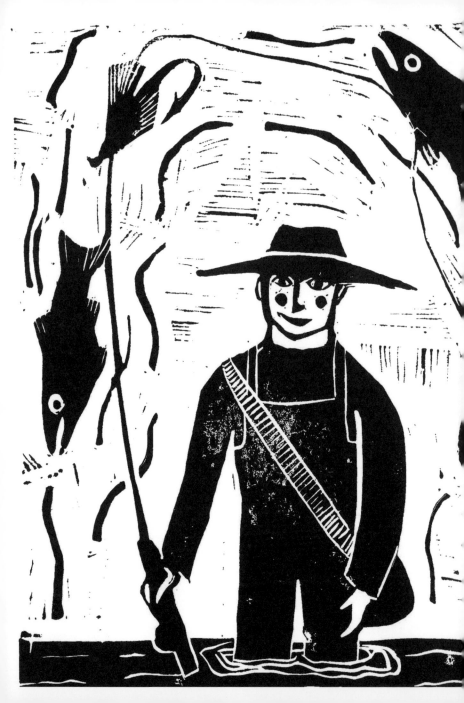

THE
Angler

Watch them still for hours on end
Like stooping herons on a rushing bend,
Half sunken along the river's tide,
Angling their line with lure to guide.

They wait the storm to pass on by,
Come grayling to jump and salmon fly,
Then set their eyes on its polished top,
To throw in time on the current to drop.

This kind knows the course by hand,
Where waters deep meet silted land,
Is best to know the coming weather
Or turn of season from passing feather.

You'll hear them hum, when lost in thought
In time of flow and rapids caught;
Not always there to launch their fly
But simply be, with land and sky.

How a life sought in peaceful mind
Is found in time 'mid nature's kind.

THE
Sailor

In the fair winds we see them claim
Their cherished crafts of beloved name,
These dogs of sea with bearded steel
That ride the waves with buoyant feel.
He sends her port from harbour rung,
Crying the lines of shanties sung
To send her sail aloft and free
And face the gape of Mother's sea.
He tacks at speed to force the knots,
Past scaling isles, through hidden lochs;
The one who sees the changing lines
Of our littoral path, for beauty shines.
Where waves awash in coastal beat,
Come gannets dive and herrings bleat,
Await the hour of copper sun
To light the ways where dolphins run.
With air to meet he stands astern
To waters clear in wishful yearn,
All masters of the coming wave,
A life aboard forever crave.

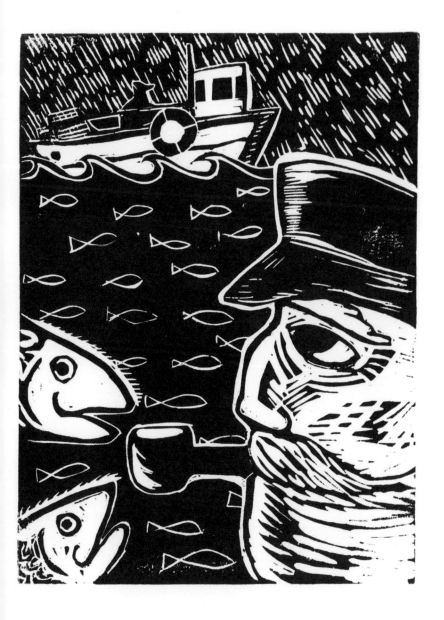

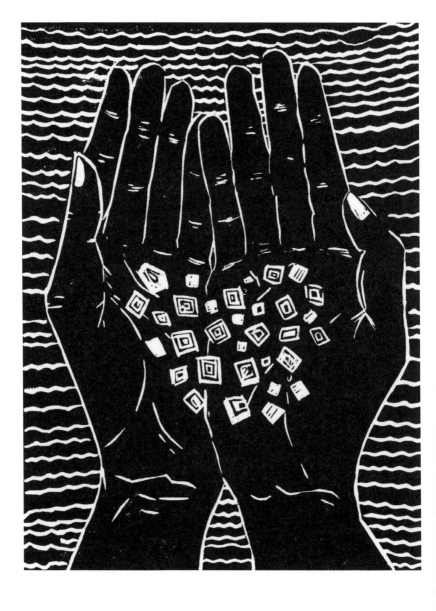

THE
Salt
Harvester

Walk beside the water's edge
Where the air is sweet and purer still,
Come find the kind who watch and wait
The rising tide of beauty's strait.

See them stand on wetland marsh
To lure the flood of salty sea,
And tap the springs of western Wich,
Where nature seeps her bounty rich.

Out to source the same in kind
Through muggy steam and burning brine,
See folk that heat and swirl to make,
And capture the sea in glistening flake.

In time they wait for purest white
To drain and dry 'til morning light,
For now they take to taverns nigh,
And tipple the last of evening by.

How such as these do salt the earth,
A thousand years spent finding worth
To cure, season and balance taste,
Upon the lands a history traced.

THE
Sea Fisherman

They rise together to sea, as one,
From shore of isle or coastal town,
For these are our fishers of old, and now
At helm they ride to waters deep.

Up before the sunshine's rise,
From Hastings south to heights of Mull,
They throw their nets that wishful sink,
A catch they hope will help them by.

Early in such hundredth hour
They pray for waters set to calm,
Where bones are pushed and torn in two
On waves that crash on torrid nights.

How day and night are lost in one
Come the hour at end, yet still they're out,
For once they saw such bounteous catch,
Before larger hands bought their part.

Most often built on family tree,
They pass the ways to younger weans,
Who find their legs on the sea to stand
And learn the ropes with steely hand.

Not one of these will ever see
A life away from the water's ride;
Souls who know their history past
Will serve their fathers on every tide.

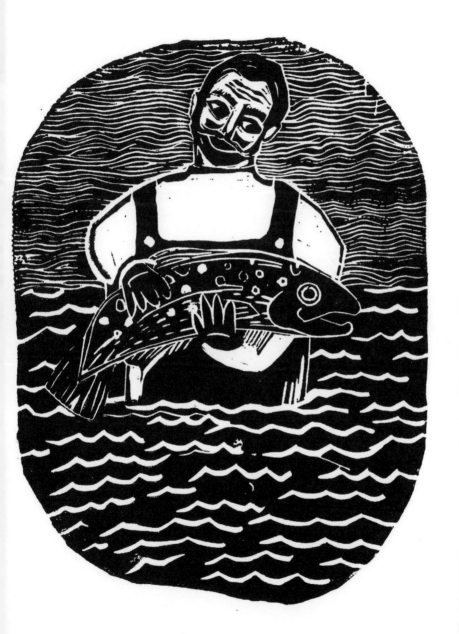

Glossary

The Baker
Banneton: A basket used in baking to hold the bread in place while proving.

The Brewer
Mash tun: A container where malt is mashed and turned in enriched hot water.

'God is Good' or 'Goddes Good': An archaic term for yeast that is added during the brewing process.

Wort: A mixture of water and crushed malt created in the mash tun.

'frequent Act': In reference to the Gin Acts instated in the eighteenth century.

The Cheesemaker
Steam jacket: A container lined with wire to heat and control the temperature of milk.

The Dry Stone Waller
Dip: A liquid mixture that shepherds and farmers channel their sheep through to protect them from diseases.

Face: A collective term for the entire dry stone wall or the side of a dry stone wall.

Fold: An enclosure for livestock.

Lift: In reference to the 'First Lift' and 'Second Lift' of a dry stone wall. The First Lift makes up the majority of the lower section of the wall and the Second Lift makes up the majority of the upper section.

Pins: Small stones tightly positioned in the wall to hold the face stones in place.

Packing: Stones used to fill gaps within the dry stone wall.

Cope or topping: The top section of the dry stone wall.

'centuries of Act': A reference to the Enclosure Acts when the British countryside was privatized.

Bee bole: A hole in the wall for a skep to be placed.

Skep: A wicker basket for a bee hive.

The Falconer
Creance: A long line of rope attached to the bird of prey when it learns to fly.

The Farrier
Rasp: A tool used to shape and smooth material.

The Forager
Beet: An abbreviation of sea beet, an edible type of sea vegetation.

Dock pudding: A traditional dish from the British Isles made up of seasonal leaves, mainly meadow bistort.

The Forester
Boring tool or increment borer: A tool used to extract a fragment of the tree in order to study it.

The Gamekeeper
Beat: The process of flushing out game birds from the undergrowth.

The Henkeeper
Stag: The dead branches of a tree that die back due to its vascular system being unable to sustain its crown.
Lea: A meadow or area of open land.

The Ploughman
Stetch: A bank of ploughed soil made between two furrows.
Tilth: The state of the soil, in relation to it being suitable for sowing seed.
Lip: An abbreviation of 'seedlip', a basket that carries seed for sowing.
Fiddle: A device made of wood and canvas that carries seed for sowing.
Caddow: An archaic term for a jackdaw.
Dolly: A child's dolly made out of corn during the harvest.

The Potter
Towns of six: A reference to the six pottery towns of Stoke-on-Trent; Burslem, Fenton, Hanley, Longton, Stoke-upon-Trent and Tunstall.

The Sailor
Tack: A nautical term for changing direction in the boat using the sail to catch the wind.

The Shepherd
Tup: An alternative name for a ram.
Spring: An abbreviation for a spring lamb.

The Thatcher
Yealm: A bundle of organized straw for thatching.
Course: A horizontal level of yealms on a thatched roof.
Crook: A metal point affixing thatching materials to the roof structure.
Sway: A long piece of thin wood, often hazel or ash, which fastens the course to the roof structure.
Spar: A whittled length of wood, often hazel, which is pointed and twisted to pin thatching material.
Ridge: The peak of a thatched roof covered by a ridge of straw, sedge or heather.

The Winemaker
Scale: In reference to the Oechsle scale, which measures the density of the must.
Racking: A filtration stage during the winemaking process.
Must: The crushed mixture of grapes: juice, stems, seeds and skins.

Acknowledgements

Firstly, we would like to thank the remarkable rural lives that inspired us to create this book, to all those who we have visited and spent time with, thank you for your patience and your generosity in giving up your time for us. Those, such as, Paul and Sarah at Appleby's, birdwatcher and author of *Cuckoo*, Professor Nick Davies, Jonny and Dulcie at Fen Farm Dairy, Alison, David and Jess at Halen Môn, Martin and Beth at Moyden's, Chris and Joanna from Pump Street Bakery, and to the many other wonderful rural lives we've met along our journey. Thank you to Pavilion Books for giving us the opportunity to publish *Our Isles* and encourage the exploration and celebration of our extraordinary countryside and the rural lives that exist within it. Particular thanks goes to Laura Gladwin, Bella Cockrell and Michelle Mac for their instrumental work and advice in creating the final book, Katie Cowan for giving us her endless enthusiasm and support, and Stephanie Milner for seeing the potential in the book. A huge thank you to our families for the invaluable support they have given us over the last few years towards making this book, this book is for you; Alice, Arthur, Barbar, Gary, Harry, James, Max, Minnie and Serena. Thank you all.

First published in the United Kingdom in 2020 by
Pavilion
43 Great Ormond Street
London
WC1N 3HZ

ISBN 978-1-91164-135-3

A CIP catalogue record for this book is available from the British Library.

10 9 8 7 6 5 4 3 2 1

Reproduction by Rival Colour Ltd, UK
Printed and bound by Toppan Leefung Printing Ltd, China

www.pavilionbooks.com